Harry Clarke & His Legacy

The Stained Glass in St Joseph's Church, Terenure

First published in 2017 by
Liberties Press
www.libertiespress.com

Distributed in the UK by
Casemate UK
casematepublishing.co.uk

Distributed in the United States and Canada by
Casemate IPM
casematepublishers.com

Copyright © Patricia Curtin-Kelly, 2017
The author asserts her moral rights.
ISBN (print): 978-1-910742-97-6
ISBN (e-book): 978-1-910742-98-3

2 4 6 8 10 9 7 5 3
A CIP record for this title is available from the British Library.
Cover design by Clodagh Evelyn Kelly
Printed in Poland by JBConcept

Harry Clarke & His Legacy
The Stained Glass in St Joseph's Church, Terenure

Patricia Curtin-Kelly

Contents

Internal Map of Stained Glass Windows

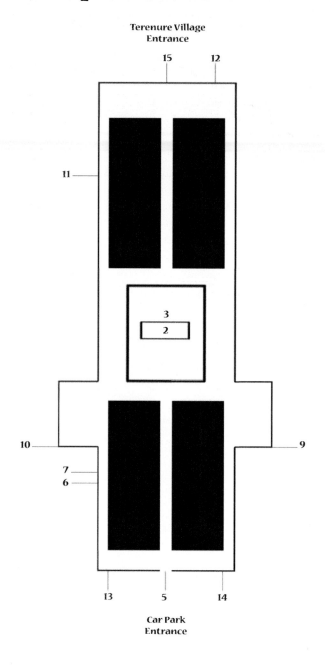

List of Illustrations

Foreword

The foundation stone for the current St Joseph's Church, here in Terenure, was laid in 1902, and it was formally dedicated in 1904. The church was extended in 1952, leaving us with a nave both in front of and behind the altar – which is really quite unusual. I often refer to preaching here as being like watching Wimbledon: I have to swing my head to front and back! To the untrained eye, these front and back naves are mirror images of each other. However, when looking for differences, we are drawn to the Harry Clarke windows, and the oddity becomes the uniqueness of this church.

Our Harry Clarke windows were installed over many decades, and make St Joseph's more than a 'cornucopia' for the stained-glass lover. Of particular interest is that all of the stained-glass windows in the church are by either Harry Clarke or the Harry Clarke Studio. Thus, in one place, in this church we have a unique example of the spectrum of Harry Clarke's work and that of his studio. We are very proud of this fact, and intend to maintain these national treasures for future generations to admire and appreciate. A particular publication on the Harry Clarke widows in St Joseph's Church is long overdue. Congratulations to Patricia Curtin-Kelly for her sterling work and, in this regard, I am delighted to commend this joint project.

I hope this publication will become an essential text for students of Harry Clarke. It will also make an ideal gift for our parishioners and their loved ones abroad, who have admired these windows for generations. Overall, it will provide an education for us all, in the wonder of Christ's life, death and resurrection.

Fr Philip Bradley
Administrator
St Joseph's Church
Terenure
Dublin

Acknowledgements

No book like this is written without a helping hand, and I should like to express my thanks to Damien Darcy, Paul Donnelly, Brendan Dunleavy, Noelle Dowling, Brian Kirby, Ken Ryan, Ruth Sheehy and John Turpin. A very special 'thank you' to Father Philip Bradley, Administrator of Terenure Parish, and Pauline Doyle, of the Terunure Parish Council, for their encouragement, interest and support for this project. A big 'thank you' to Seán O'Keeffe at Liberties Press for his support. A final 'thank you' to my husband, Bryan Kelly, for his continuing and unfailing support, and my daughter, Clodagh Kelly, who also contributed her design and photographic expertise.

Introduction

Terenure is a bustling suburb on the south side of Dublin city. Like many other parts of Dublin, Terenure started as a rural area, eventually became a village and inevitably became part of the suburbs of Dublin city. The name 'Terenure', from the Irish '*Tír an Íúir*', means 'the land or district of the yew tree'. As its Gaelic name indicates, Terenure existed as a separate entity before the coming of the Normans.

Some of the first buildings in the area were a circle of cottages built around 1801. For a time, the area was known as 'Roundtown', until 1869, when it reverted to 'Terenure' by order of Sir Robert Shaw (1774-1849)[1]. Sir Robert lived in the nearby Bushy Park House, which is now Our Lady's School, a girls' school founded by the Religious of Christian Education, a French Order of nuns. Another school in the Terenure area that has an association with the Shaw family is Terenure College. This was founded in 1860, by the Carmelite Order, as a boys' boarding school[2]. Today it is a thriving boys' day school. A well-known descendant of Sir Robert is George Bernard Shaw (1856-1950), the Irish playwright and critic, who won the Nobel Prize for Literature in 1952.

[1] Essie Harrington & Deirdre Brown, eds., *Memories of Terenure*, The Heritage Council, Dublin, 2000 – p.9

[2] Joe Curtis, *Terenure*, The History Press Ireland, Dublin, 2014, p.48

Other famous people have had an association with Terenure. For example, the internationally noted Irish writer James Joyce (1882-1941) was born on 2 February 1882 at 41 Brighton Square, which is nearby, and was baptised in St Joseph's Church. His mother, May Joyce (née Murray), was born in 1859 and reared in the pub at the Terenure crossroads. This pub was owned by her father, John Murray, and is now known as Vaughans, the Eagle House. There are plaques on both buildings to commemorate these associations. Terenure Cross (Vaughans Corner) was at one time a terminus for the city tram; this is mentioned in James Joyce's *Ulysses*.

Originally, parishioners from the area attended the church in Rathfarnham, but this proved to be too small for the growing con-gregation. In 1856, work on Terenure Church was instigated by Canon Daniel Byrne (1864-78), parish priest of Rathfarnham, who planned to build a new church and school in the locality. He held a public meeting, and the considerable sum of £150 was raised in subscriptions[3]. Canon Byrne purchased a field, in what is now part of the Terenure crossroads area, and both a church and a school are still on these grounds today.

[3] Brian MacGiolla Phadraig, *History of Terenure*, Veritas Co. Ltd, Dublin, 1954 – p.45

Building the School

The school was constructed before the church: Canon Byrne's plan was to build a school for both boys and girls. However, before it was completed, the Presentation Order decided to build a school for girls in Terenure. As a result, it was agreed that the girls would attend the nuns' school and that the newly built girls school would become a Chapel at Ease. The boys' school was originally called 'Roundtown Boys National School' and is known today as 'St Joseph's Boys National School'. When the school opened in 1866, it had one hundred and seventy-four boys in three classes[4]. This is considerably more than the pupil-teacher ratios we are used to today, and shows the need for such a development at that time. St Joseph's Boys National School celebrated its one hundred and fiftieth anniversary in 2016.

[4] St Joseph's Parish Newsletter – 06/11/2016

Building the Church

The Roundtown Chapel at Ease was built by M/s Gahan of Rathfarnham and was described in the *Freeman's Journal* as being in the early Gothic style. On 25 June 1867, the *Freeman's Journal* stated that the church was consecrated by the Cardinal Archbishop of Dublin and that a very large congregation attended. The article continued:

> The building, having been blessed by His Eminence, a solemn high mass was celebrated with the Very Rev. Canon Forde VG PP officiating. After the Gospel, the Cardinal Archbishop preached an important sermon from the Epistle of the day, taking occasion to congratulate the Very Rev. Canon Byrne, his clergy and parishioners on the completion of the new temple of Catholic worship, so much needed in the locality.

The foundation stone for the present-day St Joseph's Church was laid in 1902. It was dedicated, in 1904, by Reverend William Walsh, Archbishop of Dublin. The parish priest at the time was Canon Terence Anderson (1897-1916). The architect for the church was William Henry Byrne (1897-1905) of William Henry Byrne & Son of Suffolk Street, Dublin. (The original phase was designed by the architect William Geraty Clayton (1872-1948), while he was working for the same firm.) The builders were Michael Meade & Sons of Pearse Street (formerly Great Brunswick Street),

Dublin[5]. On 15 December 1916, a bill from W. H. Byrne & Son sets out a cost of £19,906.15.0d to build the church[6].

The cost of the building was much greater than had been anticipated: not less than £20,000, which included the cost of the high altar and the church furniture. As a result, the church was completed with the exception of a tower and spire[7].

St Joseph's Church (Fig. 1) is an asymmetric Romanesque building, separated from the street by high railings and a gate. These were probably commissioned by the Dublin architectural firm of Ashlin & Coleman in 1922[8]. It is constructed in Wicklow granite on the outside and Aberdeen granite on the inside. There are polished granite pillars with carved capitals, resting on black marble bases, inside the church. Hanging on the inside wall of the church, to the right of the village-door entrance, is a framed citation from Pope Pius X (1815-1914). The Latin translation reads:

> For our dear son (Terence Canon Anderson) who erected this church we beg of the Lord all blessings and the resources necessary to complete the tower and we impart to him affectionately the Apostolic Benediction. The 7th day of May in the year 1909. Pius X Pope.

Due to a lack of funds, the intended belfry tower was never completed. There is a large bell on the grounds, caged by railings, on the right-hand side of the village entrance to the church. This was donated by the Doyle family in 1903. Perhaps it is still waiting for the belfry to be completed!

[5] Irish Architectural Archive, Merrion Square, Dublin 2

[6] *Church Building: Dioceses of Dublin 1800-1916*, Dublin Diocesan Archives, Holy Cross College, Clonliffe Road, Dublin

[7] *The Irish Builder & Engineer*, 7/4/1904 (Building News Section)

[8] Irish Architectural Archive, Merrion Square, Dublin

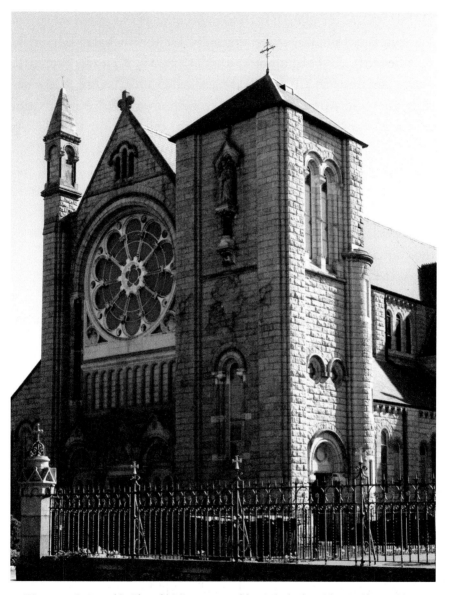

Figure 1 St Joseph's Church, Terenure, Dublin (Clodagh Evelyn Kelly, Dublin)

In 1952, as the church had again become too small for the growing congregation and, at the urging of Dr John Charles McQuaid (1895-1973), Archbishop of Dublin (1940-1972), it was extended. Many parishioners remember the packed church before the extension was built. Rows of forms had to be put out, between the front seats and the altar-rails and altar-steps, to cater for the crowds[9]. As the church is bounded on three sides by the road and buildings, it could only be extended backwards. This extension, which has doubled the length of the church, has left the altar in the centre of a long nave. As a result, it now has two entrances, one on the village side, and the other accessed from the car park at the rear of the church.

At the Terenure-village entrance, there is an unusual tympanum with three stone carvings of Mary, Joseph and Christ on a gold mosaic background. There are coloured mosaic depictions in other tympanums around the outside of the church building. These are: Pope Pius X, over a side door on the east side of the church; St Joseph, holding a lily, over the door of the car park entrance; and St Brigid, holding an oak branch, on the west side of the church. There is also a statue of St Joseph, high up on the right-hand-side wall, at the village entrance to the church. This was donated, in 1925, by John and Teresa Power of Healthfield Road, Terenure.

[9] Essie Harrington & Deirdre Brown, Eds., "Memories of Terenure", The Heritage Council, Dublin, 2000 – p.61

Church Furnishings

Under the altar-table in the church, there is a marble sculpture of *The Dead Christ* (Fig. 2) that is reminiscent of one executed by the renowned Irish sculptor John Hogan (1800-58). There are four known versions of this sculpture by Hogan or his associates[10]. The first depiction of Hogan's sculpture is in St Teresa's Carmelite Church in Clarendon Street, Dublin (1829). The second is in St Finbarr's South Parish Church, Cork (1829), and there is a third depiction in the Basilica of St John the Baptist in Newfoundland, Canada (1854). In addition, there is a plaster cast of the sculpture in the Crawford Art Gallery in Cork. Hogan was a neo-classical sculptor who spent his formative years in Cork, under the tutelage of the renowned architect Sir Thomas Deane (1772-1847), who encouraged him to carve in wood and stone. Hogan also studied and worked in Rome (1824-49) and returned to live permanently in Ireland in 1849 with his Italian wife and six children[11].

It is not known who depicted the sculpture of the *Dead Christ* in St Joseph's Church but it is clearly based on Hogan's magnificent original work. It depicts a reclining figure of the dead Christ which is both idealistic and naturalistic. His head is resting on a stone, over which his long hair is strewn. There is a crown of thorns, one

[10] John Turpin, "John Hogan – Irish Neoclassical Sculptor in Rome," Irish Academic Press, Dublin. 1984

[11] Irish Architectural Archive, Merrion Square, Dublin

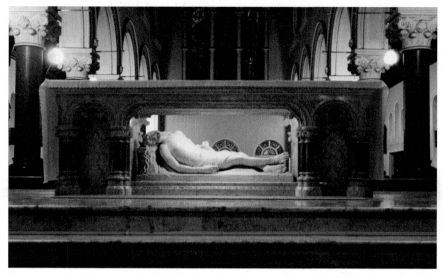

Figure 2 The Dead Christ, possibly by James Cahill (d. 1870),
(Clodagh Evelyn Kelly, Dublin)

of the attributes of the Crucifixion, propped against the stone. It is possible that this sculpture was executed by James Cahill (d. 1890), who was Hogan's studio assistant at Wentworth Place (now Hogan Place), Dublin. Cahill, who was from County Westmeath, studied at the Royal Dublin Society's School and spent some months in Rome. On his return to Dublin in 1853, he entered Hogan's studio as a student and subsequently became his assistant[12]. The inscription on the base reads: 'Lord have mercy on the soul of the donor, Mrs. Jane Grehan, late of Drumcondra. RIP.'

There is an unusual crucifix, high above the altar (Fig. 3). This was commissioned by Father Joseph Union, parish priest of Terenure (1954-72), who clearly wanted a unifying feature to link both sides of the altar table in the extended church. It was executed by John Haugh (1921-2007), an emerging Irish artist at the time. Haugh was born in County Clare and trained at the Arts & Crafts

[12] Walter G. Strickland, "A Dictionary of Irish Artists", Maunsell & Co. Ltd, Dublin & London, 1913

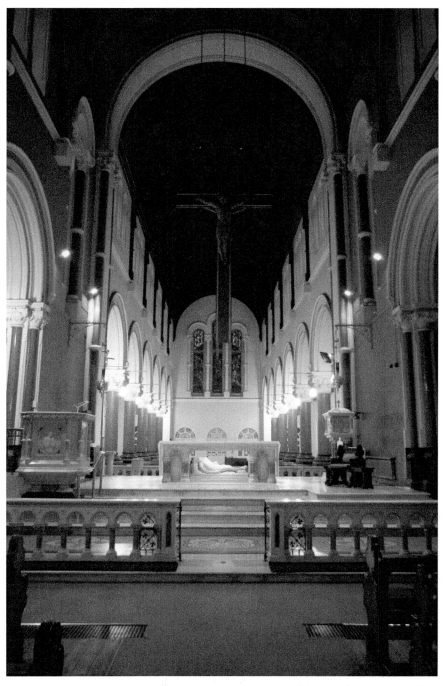

Figure 3 Internal View, St Joseph's Church, Dublin, with Crucifix
(Clodagh Evelyn Kelly, Dublin)

11

School, Glenstal Abbey, County Limerick, after which he travelled and studied. On his return to Dublin in 1949, he worked as a professional wood-carver and sculptor in church and folk art, before settling in Carlingford, County Louth[13]. The corpus of Christ is carved in African white wood and stands out against the dark mahogany cross, which is banded in gold[14]. The unusual feature is that the figure of Christ is replicated on the back and front of the cross, thus uniting both sides of the long apse in the building. Haugh's widow, Eileen Haugh, said that he was very proud of this work and that his name or initials should be carved at the base of the sculpture.

On the left-hand side of the altar, there is a three-sided white marble pulpit which has a carving of a saint on each side. The inscription reads: 'Pray for the donor, Mrs. M.A. O'Brien, Glenmore, Terenure Park, 1906.' In the right-hand corner, facing the altar, there is a plaque to commemorate the one hundred and fiftieth anniversary of the coming of the Presentation Order of nuns to the parish. The inscription reads: 'In gratitude to the Presentation Sisters for their presence and dedication to ministry in the parish of Terenure 1866-2006, *I linte Dé go Geasta sinn.*'

The crowning glory in the church, however, is its stained-glass windows, which were executed by the renowned Irish artist Harry Clarke (1889-1931) and his studio. It could be said that the first commission for this church firmly established Clarke's reputation as a stained-glass artist and these windows, in particular, are among the artistic gems of Dublin city. The church also offers a unique record of both Harry Clarke's work, at the height of his career, and his legacy. Apart from the two windows by Clarke, all of the other stained-glass windows in the church were designed by artists trained by Clarke and who managed the studio following his untimely death.

[13] *Argus* newspaper, Dundalk, County Louth, 22/08/2007

[14] Sunday newspaper cutting, 29/01/1956, Dublin Diocesan Archives, Holy Cross College, Clonliffe Road, Dublin

Harry Clarke

Harry Clarke (Fig. 4) was born in Dublin in 1889 and was a leading figure in the Irish Arts & Crafts movement. His father Joshua (*c.* 1868-1921) came to Dublin from Leeds, in England, in 1877 and in 1886 established a business involved in furnishing and decorating churches. He subsequently expanded this to include a stained-glass division. The company was called J. Clarke & Sons and was located at North Frederick Street, Dublin. His mother was Brigid McGonigal, from Cliffony, County Sligo, and he had two sisters, Kathleen and Florence, and a brother, Walter [15]. During his short life, Harry was one of the first indigenous stained-glass artists to achieve international recognition. He was also a renowned graphic artist.

Harry was educated at Belvedere College, Dublin (1896-1903), where his ability in drawing was noted. On leaving school, he joined the family business, as did his brother Walter (*c.* 1887-1930). Harry worked there under William Nagle (1853-1931), one of the artists employed by his father, who taught him drawing and design for stained glass[16]. He studied at night at the Metro-politan School of Art, Dublin (1905-10), under the influence of A. E. Child (1875-1939), who was also manager of *An Túr Gloine*

[15] William J. Dowling, Dublin Historical Review, Vol. XV11, 1961-1962, Old Dublin Society, Dublin – p.55

[16] *ibid.* – p.55

Figure 4 Self-portrait Ink Drawing by Harry Clarke (1889-1931)
(Collection Dublin City Gallery – The Hugh Lane, Dublin)

(The Tower of Glass). *An Túr Gloine* was established in 1903 by the well-known Irish portrait artist Sara Purser (1848-1943) to introduce an indigenous stained-glass business in Ireland, as most of such work was imported from England and Germany at the time. Harry also studied at the National Art Training School, Kensington, London (1906). He won the gold medal for stained glass in a national competition, organised by the Board of Education, in three successive years (1911-13). In 1914, he was awarded a travelling scholarship by the Department of Agriculture & Technical Instruction: he used this to study stained glass in France. Harry was influenced by the medieval stained glass he saw at that time, as well as by other artists, such as the English artist Aubrey Beardsley

(1872-98), and this is evident in his work. However, he developed his own unique style, with its exquisite drawing details and jewel-like colours, and succeeded in adapting modern European art to an Irish style.

Harry married Margaret Crilly (1884-1961), a fellow student at the Dublin Metropolitan School of Art. She studied there under the well-known Irish artist Sir William Orpen (1878-1931), who considered her to be one of his most promising students. Margaret Clarke also became well known in her own right and was a talented portrait artist.

In 1921, following his father's death, and in spite of persistent bad health, Harry took over the running of his father's studio, along with his brother Walter. Walter looked after business matters and Harry was in charge of the stained-glass department. Shortly after Walter's death, in 1930, Harry set up his own studio, called 'Harry Clarke Stained Glass Ltd'. Due to ill health, he had to go to Davos in Switzerland for treatment; he died there in January 1931, at the age of forty-one. Before his early and untimely death, he had produced a considerable body of work; some of the best examples of his stained-glass windows are here in St Joseph's Church. Other examples include the nine windows in the Honan Chapel at University College Cork; the *Geneva Window* at the Wolfsonian Institute in Miami, Florida; and the *Eve of St Agnes* in the Hugh Lane Municipal Gallery, Dublin.

First Harry Clarke Commission

In 1917, Harry Clarke was in competition with his father, Joshua Clarke, for the commission to execute a stained-glass window for St Joseph's Church in Terenure. Harry won the commission. The window was instigated by Father John Healy (1837-1925), who was parish priest of Terenure (1917-24) at the time. Father Healy was somewhat apprehensive about Harry Clarke's reputation as an artist: he was considered to be a little too avant-garde by some people at the time. His style of drawing was new in the area of ecclesiastical art, being very different from the excessively sentimental style of religious art at the time. Nevertheless, the parish priest, Father Healy, seems to have given Harry a free hand in terms of the design. The priest was pleased with the window, which he described as a 'genuine and authentic art, not too modern'.

This very large, three-light window depicts the Crucifixion and a multitude of Irish saints. It was originally sited behind the high altar but was moved, to its current position at the back of the church, when the building was extended in 1952. Harry Clarke called the composition *The Adoration of the Cross by Irish Saints* and received £500 for his work[17]. In a review in the *Irish Times*, it was stated that this window was probably 'the best Harry Clarke has executed'[18].

[17] Brian MacGiolla Phadraig, *History of Terenure*, Veritas Co. Ltd, Dublin. 1954 – p.55

[18] *Irish Times*, 07/04/1923

The donor was Major Laurence Gorman, of Brighton Road, who left £500 for the erection of a stained-glass window, depicting the Crucifixion, to be placed behind the high altar in St Joseph's Church. Father Healy made all the arrangements. The window was to commemorate Major Gorman himself, and Edward and Jeannie de Verdon Corcoran. This sum was not sufficient, however, to cover all the costs involved. Miss Fanny Andrews, of 'Clarendon', Terenure Road East, stepped into the breach and donated the balance of £200. As a result, the window was erected free of debt[19].

The window was dedicated in 1920 by Dr Miller, former Bishop of Johannesburg[20]. A special souvenir booklet was printed to mark the occasion. It included appreciation essays from Thomas Bodkin (1887-1961), Director of the National Gallery of Ireland (1927-35); Miss Kathleen Fox (1880-1963), an Irish artist; Captain Ste-phen Gwynn (1864-1950), a journalist and Member of Parliament for Galway (1906-16); and Sir John O'Connell (1868-1943), a philanthropist and activist in Irish cultural life. The booklet also included the text of a long sermon preached by Father Healy on the day, as well as a short history of the origins of stained glass. The proceeds of this booklet were to help meet the annual interest on the church's debt.

The Adoration of the Cross by Irish Saints (Fig. 5) is a three-light window; the three lights are tied together by a uniform background. The background consists of a spectacular orange and red sunset rising above a crescent-shaped row of dark-green pine trees. It is almost like heaven is above, the earth is below, and between them is the dome of an orange sky over a twilight of trees. The Cross rests on the earth, yet pierces through the great dome, and there is a subtle symbolism in the arrangement of the colours. The lower portions of the three lights are dominated by rich hues of blues, greens

[19] Brian MacGiolla Phardaig, *History of Terenure*, Veritas Co. Ltd, Dublin, 1954, p.55
[20] *ibid.*

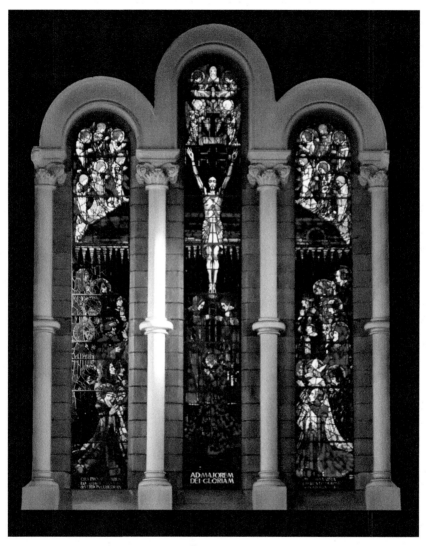

Figure 5 The Adoration of the Cross by Irish Saints (Clodagh Evelyn Kelly, Dublin)

and mauves, which sparkle in the sunlight. The band of dark-green trees, behind the pale figure of Christ, is silhouetted against the dramatic orange and red sky. This could symbolise the air of despair that is said to have spread throughout the earth from the sixth to the ninth hour of the Crucifixion. Above that, the sky becomes a golden yellow, through which a heavenly choir of angels shines, in brilliantly coloured robes. The saints are a mixture of famous and obscure early Irish saints: their names are inscribed on each individual halo. They all face the centre and are absorbed in prayer.

The top panel of the left-hand light has a depiction of six golden-haired angels, in profile. They are praying, and are wearing beautiful robes of white, red, pink and green, with wings of blue, purple, red and green. The middle and lower panels depict eleven Irish saints[21]. These are, in descending order, going from left to right:

St Coga (or Cusack) of Kilcock, County Kildare, who was a nurse to St Ciaran of Clonmacnoise, and is robed in a multi-coloured blue-hooded cloak;

St Braccan, Bishop of Ardbraccon, County Meath, who is wearing a bronzed hooded cloak;

St Erc, Bishop of Slane, who was St Patrick's lawyer; his hands are joined in prayer and he is wearing a beret-type cap;

St Conlaith, Bishop and patron of Kildare, who was Spiritual Director of St Brigid's Convent, and her chief artist and artificer; his head is bowed, and he is wearing a red robe and hat and is holding a staff;

St Kevin, a sixth-century hermit and founder Abbot of Glendalough, who is holding a golden staff and wearing a blue hat and cape, adorned with a large brooch;

[21] Brian Mac Giolla Phadraig, "History of Terenure," Veritas Co. Ltd, Dublin, 1954 – p.57-58

St Ita, Abbess of Killeedy, County Limerick, who is also known as the Brigid of Munster, and is wearing her traditional blue cloak;

St Sedulius, an eighth-century Bishop of Dublin, who is wearing an ornate multi-coloured maroon cloak and hat, and whose head is bowed;

St Fintan, Abbot of Clonenagh, County Laois, who was a famous seventh-century anchorite; his head is bowed and he is wearing a bronze cloak decorated with Celtic spirals;

St Berac, Abbot of Cluain Cairpthe and patron of Kilbarry, County Roscommon, who is shown in profile;

St Patrick, who is known as the Apostle of Ireland, is kneeling, with his hands joined in prayer and his head bowed; he is dressed in his traditional green robes and has a large ring on his green-gloved hands;

and St Colga, Abbot of Clonmacnoise, who was author of the eighth-century *An Scuab Chrabhhaidh* (The Besom of Devotion); his head is bowed and he is shown in silhouette.

The inscription, in Latin, reads: *Ora pro animalus Eduardu et Joannae de Verdun Corcoran.* (Pray for the souls of Edward and Joanne de Verdun Corcoran).

In the centre light, Christ is depicted on a thin Cross with the inscription 'INRI' (*Jesus Nazarenus Rex Iudoeorum* – Jesus, the Nazarene, King of the Jews) nailed at the top. The Cross is in the shape of a Greek Cross, and is outlined in green. In the background, the brilliant orange and red sunset adds a dramatic contrast to Christ's pale and slender body. Harry Clarke posed in a photograph for this work so as to be able to get the correct curved position[22].

[22] Nicola Gordon-Bowe, *Harry Clarke: The Life & Work*, The History Press Ireland, Dublin, 2012, p.176

The depiction is almost as if Christ on the Cross is soaring upwards, uniting earth with heaven, where a choir of angels frame the Holy Spirit, who is depicted in the form of a dove. The five angels, at the top of this panel, are wearing gold and white robes with wings of blue and crimson. In the lower panel is a depiction of Mary, the mother of Christ, St John and Mary Magdalene, who are all grieving at the foot of the Cross. Mary, standing to the right of the Cross, is wearing a highly decorated hooded robe of blue, green and maroon, which has floral motifs and geometric shapes. Her face is depicted in a different style from the others and could be that of a grieving Irish mother. St John, standing beside her, to the left of the Cross, is wearing a robe of blue and gold. Mary Magdalene, kneeling at the bottom of the Cross, is wearing a sumptuous robe in a kaleidoscope of blue and scarlet colours, with her long golden hair falling around her shoulders. The inscription, in Latin, reads: *Ad Majorem Dei Gloriam* (To the Greater Glory of God).

The top panel, of the right-hand light, depicts six angels wearing decorated robes of white, blue, green, gold and crimson, with wings of green, gold, blue and purple. The main and lower panels have depictions of ten Irish saints[23]. These are, in ascending order, from left to right:

St Munchin, patron saint of Munster, who is robed in blue and turquoise and is wearing a hat and cloak;

St Albert, a seventh-century Bishop of Cashel, County Tipperary, who is wearing a green hat and cloak and whose hands are clasped in prayer;

St Gobnait, Abbess of Ballyvourney, County Cork and patroness of beekeepers, who is wearing a multi-coloured cloak and a cloche hat;

[23] Brian Mac Giolla Phadraig, *History of Terenure*, Veritas Co. Ltd, Dublin, 1954, p.58

St Attracta, Abbess of Killaraght, Lough Gara, County Sligo, who is wearing a red and white headdress with a crimson and gold robe; her head is bowed and her hands are joined in prayer;

St Laurence, Abbot of Glendalough, Archbishop of Dublin and patron of the Dublin Diocese, who is holding a staff; he is wearing a blue headdress and cloak;

St Brendan, the famous fifth-century navigator of Clonfert and Ardfert, who is wearing a purple cloak and an ornamented hat and whose hands are clasped in prayer;

St Fechín, Abbot of the Monastery of Fore, County Westmeath, who is shown in silhouette and is wearing a brown hood and cloak;

St Colman, Abbot and founder of the monastery at Kilmac-dough, County Clare, who is wearing a light green hat and flowing cloak and whose hands are joined in prayer;

St Finbarr, patron saint of Cork, who is wearing a crimson and gold hat and robe; his head is bowed and his hands are joined in prayer;

and St Brigid, Abbess of Kildare, who is one of the three patron saints of Ireland, along with St Patrick and St Columba; she is kneeling, her hands are clasped in prayer and she is wearing her traditional blue robe with a lighter-coloured hood.

The inscription, in Latin, reads: *Ora pro Anima, Laurentil Gorman Donatoris R.I.P.* (Pray for the Soul of Laurence Gorman, Donor, RIP).

This heavily painted three-light window displays Clarke's magnificent talent for outstanding artwork. It is painted in a style that is as vibrant as one might expect in a vigorous medium such as stained glass. The figures of St Patrick and St Brigid are shown more fully than the other saints, and fill the lower portion of the two side-lights. All the saints are wearing highly ornate robes and a variety

of plain and decorated headdresses, from hoods to hats and crowns. In conceiving what must have been a difficult and awkward design for a crucifixion scene, Harry Clarke took an unusual approach. He executed the scene in a vertical rather than a horizontal composition, across the three lights. By placing the Cross entirely in the centre light, he avoided the problem of outstretched arms being severed (as they would have been if they had been stretched into the other two lights). Instead, he filled the side-lights with a host of Irish saints.

In the Middle Ages, artists used coloured-glass depictions as a means of conveying the teachings of the Church. It could be said that Harry Clarke is continuing this tradition. In this magnificent three-light window, he seems to be building an iconography of Irish saints, which might otherwise be lost or unknown, and thereby demonstrating his knowledge of historical and theological sources. He has also adopted this approach in two stained-glass windows in Holy Trinity Church in Cork: the *Adoration of the Sacred Heart by Irish Saints* and the *Adoration of the Immaculate Conception by Irish Saints*, where he has not only used the same tiered effect to depict the saints of Munster, but has also added attributes such as a bee-hive for St Gobnait, an oar for St Brendan, and so on.

Thomas MacGreevy (1893-1967), Director of the National Gallery of Ireland (1950-63), said that this window is 'probably the most dramatically brilliant piece of modern stained glass to be seen anywhere'. On 22 May 1920, Sir John O'Connell said in an article in the *Daily Express*: 'Mr Clarke has proved that there is no longer any reason or any excuse for those who desire to beautify our churches to go to Munich or to Birmingham'. Sir John had been instrumental in encouraging Harry Clarke to design his famous eleven windows in the Honan Chapel at University College

Cork in 1915[24], and he was also consulted by Father Healy in the commissioning of this stained-glass window in Terenure[25].

Harry Clarke's brilliant blues, purples and reds call to mind those in Chartres and Rheims Cathedrals, which he would have visited during his travels in France. Like the medieval artists, he appreciated the power of colour in stained glass. The bejewelled and decorated garments in his windows could have been influenced by the motifs in the Book of Kells. Harry Clarke was alive during the height of the Celtic Revival and, while he was undoubtedly influenced by this, he avoided the obvious inclusion of a round tower or Celtic cross in this representation of traditional Irish saints. Instead, he chose to include Irish saints – many of whom would not be familiar to us today – in a variety of sumptuous outfits. This shows his interest in Irish history, his attention to detail and research, and his knowledge of costume design.

It should also be remembered, when viewing this stained-glass window, that it was designed specifically for its original site. William Dowling said that 'since the church has been extended, the window does not have the impact on one that it used to have. It seems too far away now and surface light coming from the adjoining windows spoils it to some extent'[26]. Bearing this in mind, when viewing this window, a pair of binoculars would assist the viewer in appreciating the exquisite detail of the drawings.

[24] Patricia Curtin-Kelly, *An Ornament to the City: Holy Trinity Church & the Capuchin Order,* The History Press Ireland, Dublin, 2015, p.76

[25] Stained Glass Memorial Window, St Joseph's Terenure, *Souvenir of Dedication,* Maunsell & Co. Ltd, Dublin & London, 1920.

[26] William J. Dowling, *Dublin Historical Review,* Vol. XVII, 1961-1963, Old Dublin Society, Dublin, p.59

Second Harry Clarke Commission

In February 1922, Harry Clarke was commissioned to construct a two-light window. This depicts *The Annunciation* and *The Coronation of the Virgin in Glory* and is located on the west side of the church, beside the main altar.

The left-hand light depicts *The Annunciation* (Fig. 6), which was exhibited at the Aonach Táilteann Art Exhibition and the Gaelic Revival Festival, where Harry Clarke won first prize in the stained-glass section[27]. This light is bordered by clear glass panels decorated with colourful blossoms. The right-hand side has hanging green trees, and flowers are depicted throughout the rest of the background.

In the top panel is a depiction of an elongated figure of the Angel Gabriel, in profile. The Old and New Testament Bibles describe Gabriel with male pronouns. However, countless paintings and other depictions of the Annunciation give Gabriel a female face and body, and feminine clothing. In this depiction, Harry Clarke has chosen to present the Angel Gabriel in a female form. She is hovering over the Virgin and is wearing a magnificent purple and magenta robe, with blue cuffs. The robe is decorated with tiny floral motifs and is tied with a blue sash. The Angel Gabriel is also wearing a scarlet undergarment, with a white lace petticoat, as well

[27] Nicola Gordon-Bowe, *Harry Clarke: The Life & Work*, The History Press Ireland, Dublin, 2012, p.206

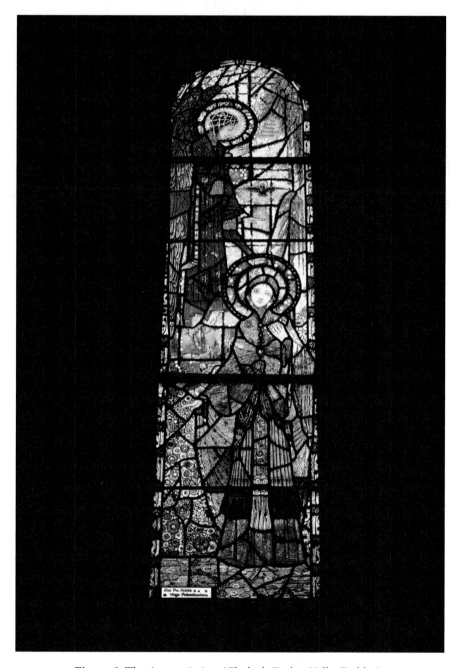

Figure 6 The Annunciation (Clodagh Evelyn Kelly, Dublin)

as dainty blue ballet slippers. She is wearing a delicate white lace headdress, encircled by a golden halo which fans out into a kaleidoscope of colour. Her wings are in various shades of crimson and orange. A dove, symbolising the Holy Spirit, is depicted beside the angel, with the Latin inscription *Ave, Grazia Plena, Dominus Tecum* (Hail Full of Grace, the Lord Is with You).

Mary is depicted, below the angel, looking out at the viewer with a wide-eyed and winsome expression. In one hand she is holding a flower, perhaps a variation on the lily, which is traditionally depicted in an annunciation setting. A multi-layered, multi-coloured halo surrounds her. Mary is wearing a robe of deep blue, embellished with blue flowers, and a deep-blue hood. She is also wearing an overskirt of turquoise, with purple trim. All these garments are tied together by a very detailed green sash. She is wrapped in a magnificent woven cloak of muted pinks and mauves. Her delicate blue shoes are resting on the ground, which has some green flowers strewn around. She is surrounded by multi-coloured flowers, culminating in a miniature *grisaille* depiction of a snowy hill town, sited beside the angel's ballet slippers. The Latin inscription reads: *Ora Pro Nobis, Virgo Potentissima* (Pray for us, Holy Virgin).

The right-hand light depicts *The Coronation of the Virgin in Glory* (Fig. 7). It has a border decorated with rows of white beads and blue crosses. Five miniature *grisaille* scenes from the life of Mary are scattered throughout the border. These are *The Annunciation, Mary Meeting With St Anne, The Nativity, Mother & Child* and *The Crucifixion*.

The top panel depicts Christ; hovering above him are four saints, who are wearing white robes. He is gazing out at the viewer, on whom he seems to be imparting a blessing. His robe is a mixture of reds, mauves and purples. He has a yellow halo with a red cross.

Mary is wearing a dark blue cloak over her head and shoulders. She is adorned by an elaborate crown, which seems to be emitting flames. The dark blue cloak reveals a light gold lining. Under this

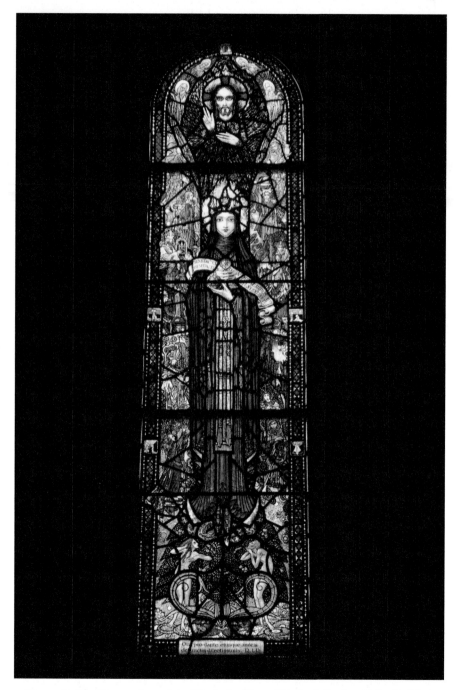

Figure 7 The Coronation of the Virgin in Glory (Clodagh Evelyn Kelly, Dublin)

she is wearing a turquoise dress, which has a light green panel down the front and an emerald green stole falling from her shoulders. She is holding a golden orb and a parchment which reads, in Latin: *Benedicta Tu in Mulieribus et Benedictus Fructus Ventris Tui.* (Blessed Art Thou Amongst Women and Blessed Is the Fruit of Thy Womb). Mary is gazing out at the viewer and her dainty blue slippers are standing on a crescent moon and hovering over the serpent that tempted Adam and Eve. She is surrounded by several figures from the Old Testament[28], who are drawn with great delicacy of feeling.

Starting from the top left-hand side, above Mary, the figures from the Old Testament are as follows. Ruth, on the left-hand side of Christ, in green glass. She is known as a Christmas saint and accompanied Naomi to Bethlehem. Rachel (meaning 'ewe') is below her, in blue glass, and she is holding an ewe. She was the second wife of Jacob (his first wife was her sister Leah) and mother of Joseph and Bayan, both of whom helped father the twelve tribes of Egypt. Ahasuerus, King of Persia, is depicted crowning his wife Esther as queen. She is wearing a pink and red robe. His court ministers are shown behind him. Esther used rhetoric to convince the king to save her people.

The scene below shows Ahasuerus choosing a dancing Esther to be his wife. This was after young virgins were commanded to gather in his presence, from all provinces of his kingdom, with the purpose of selecting a wife.

On the top right-hand side, above Mary, the figures from the Old Testament are as follows. Deborah, on the right-hand side of Christ, is depicted in green glass. The owl beside her symbolises her prophecy and wisdom. She was Israel's only female judge and was both wise and courageous. Rebecca, is below Deborah, in blue

[28] Nicola Gordon-Bowe, *Harry Clarke: The Life & Work*, The History Press Ireland, Dublin, 2012, p.215

glass, and she is wearing a dark blue, silver and gold robe and is carrying an urn on her head. She was selected to be Isaac's wife, by his father. He prayed that the girl who fetched water from the well would be the one who would marry his son. She was the mother of Esau and Jacob.

Below Rebecca, King Holofernes is depicted under a canopy, and seated on a throne. He is wearing a silver and red robe. The scene below him shows Judith, wearing a purple robe. She is looking at her maid, who is dressed in a pink and yellow robe. The maid is staring aghast at Judith, who has just decapitated Holofernes. He had planned to seduce Judith but instead she turned the tables on him: she waited until he was in a drunken stupor and hacked off his head. With her faithful maid, they returned with the head of Holofernes to display in Bathula, and thus saved her people from their enemy.

The lower panel, below Mary's feet, has a depiction of a distraught Adam and Eve, surrounded by golden apples on a purple Tree of Knowledge, as well as serpent-like motifs of the snake that tempted them. The window is signed, at the left-hand side of the lower panel, 'Harry Clarke 1923', and the Latin inscription reads: *Ors pro Dante Eiusque Amicis Defunctis Dilectissimis R.I.P.* (Pray for Him Who Gives and for Those Most Dear to Him Who Have Passed Away R.I.P.).

While identical in size, these two lights are depicted in very different styles by Clarke. *The Annunciation* is a simple yet spiritual scene, whereas *The Coronation of the Virgin in Glory* depicts a more mystical and grander scene. Both lights also demonstrate Harry Clarke's knowledge and depth of detail in relation to the people and scenes he is depicting. In an article in the *Irish Times*, Thomas Bodkin said that '*The Annunciation* is a wholly spiritual portrayal. *The Virgin in Glory* has a quality of hierarchical mysticism and grandeur.' 'He went on to say that the multitude of foreboding figures around *The Coronation of the Virgin in Glory*: 'are drawn with

such amazing delicacy of detail that they demand inspection at the closest quarter and yet, when seen from a distance, they sink into a background swirl of lovely hues enhancing the majestic figure of their queen'[29].

It could be said that these two stained-glass windows, designed by Harry Clarke, depict three very different aspects of the life of Mary. The first is the young and innocent face of Mary, where the angel is informing her that she is to become the mother of Christ. The second is the grieving face of Mary, standing disconsolately at the foot of the Cross on which her Son has been crucified. The third is the majestic face of Mary as she is being crowned Queen of Heaven by her Son.

There are also differences in style between these windows. *The Annunciation* and *The Coronation of the Virgin in Glory* are much more delicately worked than *The Adoration of the Cross by Irish Saints*. They are more reminiscent of Harry Clarke's work as an illustrator.

[29] *Irish Times*, 07/04/1923

Richard King

Following Harry Clarke's death in 1931, Charles Simmonds took over management of the studio until 1934, when he returned to England. Richard King was the chief designer in the studio during this time. In 1934, additional stained-glass windows were ordered from the Harry Clarke Stained Glass Studio; by that time, Richard King had taken over as manager and chief designer. It could therefore be assumed that he was responsible for the design and supervision of windows in the studio at the time.

Richard Joseph King (1907-74) (Fig. 8) was born in Castlebar, County Mayo. He was a renowned stained-glass artist in his own right, as well as an illustrator and pictorial artist, particularly of religious art. He also designed postage stamps for the Irish government. King was a student at the Metropolitan School of Art in Dublin and joined the J. Clarke & Sons Studio in 1928. When Harry Clarke died in 1931, soon after he had set up the Harry Clarke Stained Glass Studio, Richard King became its chief designer. He was promoted to manager in 1935[30]. He continued to use Harry Clarke's style, with its deep rich colours and intricate detail; however, his faces and figures are more realistic than those usually depicted by Harry Clarke. During his time in charge of the studio, King was responsible for works both in Ireland and abroad.

[30] Nicola Gordon-Bowe, *Harry Clarke: The Life and Work*, The History Press Ireland, Dublin, 2012, p.305

Figure 8 Richard King (1907-74) (Irish Capuchin Provincial Archives, Dublin)

In 1940, King left the Harry Clarke Stained Glass Studio to set up his own studio in Dalkey, County Dublin. This allowed him to develop a more modern style, which can be seen in many of his designs from this time.

From 1940 onwards, he was a frequent contributor to the famous *Capuchin Annual*. This was published between 1930 and 1970, by the Capuchin Order in Dublin, and was widely read both at home and abroad. Many of King's original artworks are extant in the Irish Capuchin Provincial Archives in Dublin. Other fine examples of King's stained-glass work are the six windows in St Peter & Paul's Church in Athlone, County Westmeath, the *Kevin Barry Memorial Window* in University College Dublin, and the two windows in St Mel's Cathedral, Longford, depicting *The Resurrected Christ* and *St Anne*. (St Anne was the mother of the Virgin Mary, and Christ's grandmother.)

First Richard King Commission

In 1934, an order was placed for two small roundel windows which are high up in the walls of the side chapels, right and left of the altar. This spot used to be at the end of the original church. Canon John Sheehan was parish priest of St Joseph's Church at the time (1929-50).

On the left-hand side is a depiction of *Pope Leo XIII & the Little Flower* (Fig. 9). The Pope is seated on an elaborate throne which has the papal insignia on the arm-rest. He is looking at the Little Flower, on whom he is imparting a benediction. Pope Leo (1810-1903) became the oldest Pope – he died at the age of ninety-three – and one of the longest-serving Popes, reigning for twenty-five years, from 1878 to 1903. He is wearing a magnificent swirling pink robe and a multi-coloured undergarment in pinks, blues and whites. The Little Flower, who is also known as St Therese, was a Discalced Carmelite nun from Lisieux in France. She, along with St Francis of Assisi, is one of the most popular saints in the Catholic Church. She is kneeling, with outstretched hands, and is looking up at Pope Leo. She has a halo decorated with red flowers. She is wearing a yellow headscarf, a white pleated robe and a blue undergarment. The roundel is surrounded by six petal motifs, each of which contains red and pink flowers on a deep blue background. The inscription reads: 'In memory of the descendants of Mrs Mary Kennedy.' This depiction is reminiscent of the Harry Clarke Studio window *The Little Flower before Pope Leo*, in Mount Melleray Abbey, County Waterford (1939-40).

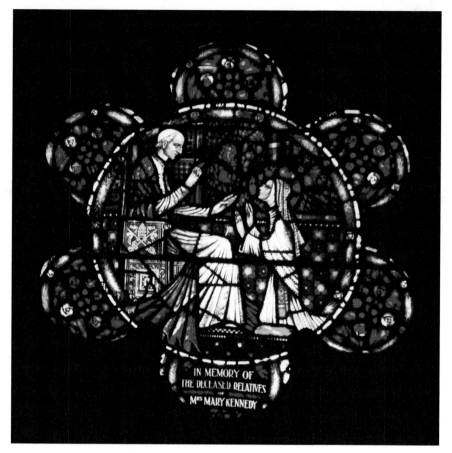

Figure 9 Pope Leo XIII & the Little Flower (Clodagh Evelyn Kelly, Dublin)

On the right-hand side is a depiction of the *Virgin Mary and St Anne* (Fig. 10). St Anne was the mother of Mary and the grandmother of Christ. St Anne is seated on the right-hand side of the roundel and the back of her chair is shaped like the head of a gondola. She has a green halo and is wearing a swirling purple cloak

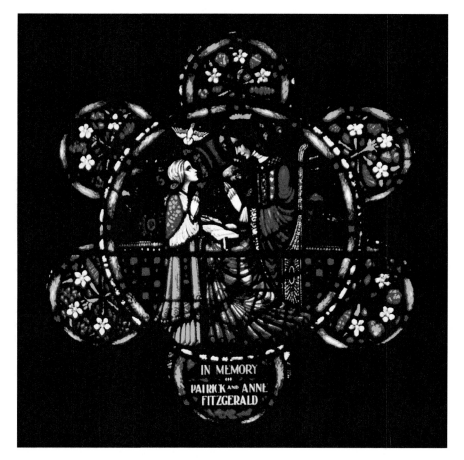

Figure 10 The Virgin Mary & St Anne (Clodagh Evelyn Kelly, Dublin)

with a mauve and pink undergarment. She has an open book on her lap and seems to be imparting a lesson to a young Mary, who is kneeling in front of her, on her right-hand side. Perhaps she is teaching her to read. Mary is bare-headed and has a red halo. A dove, depicting the Holy Spirit, is positioned above Mary's head. Mary is wearing a blue robe with a green sash, a turquoise undergarment and a deeper blue cape. Overall, the background is deeply patterned with yellows and purples on top and red star-like motifs below. The roundel is surrounded by six petal motifs, each containing three white flowers on a deep blue and turquoise background.

The inscription reads: In memory of Patrick & Anne Fitzgerald. There is a pencil drawing, in the Manuscript Library of Trinity College Dublin, of this roundel[31].

Both windows are in a daisy shape, with the scene at the centre of the roundel and floral designs in the six surrounding petals, which are richly decorated and colourful. Judging by their size and design, the two windows were clearly made to complement each other. As Richard King said, in a letter to Canon Sheehan in 1935, 'the second circular window shall be in accordance with the colour of the previous one . . . I am making the figures to a size that will make the two a complete balance and I think they should look very well indeed'[32]. Richard King has included the rich colour and drawing detail in these windows which he would have learned from Harry Clarke. These two circular stained-glass windows cost £100[33].

[31] Trinity College Manuscript Library, Dublin. Ref. 11182/118

[32] *ibid*. Ref. 6008/338

[33] Letter from Harry Clarke Stained Glass Ltd, 05/03/1936, Terenure Parish Records

Second Richard King Commission

In 1935, an order was placed for a window, which was to be placed in the mortuary, and which cost £70[34]. On 9 August 1935, in a letter to Canon Sheehan, Richard King said that 'you may rest assured we shall bear in mind your ideas and give you entire satisfaction'[35]. This is a single lancet window depicting the *Risen Christ* (Fig. 11).

The Resurrection of Christ is a central tenet of Christian belief: 'after he was put to death, he arose again on the third day'. In this window, Christ appears to be floating over a grey tomb and is holding a staff in his hand, which has a white pennant flag with a red cross on top. He has a red cruciform halo and is wearing a jewel-encrusted white robe, which contrasts with the overall deep blue background of the window. Christ is also floating over two sleeping soldiers who are positioned at the lower left-hand side of the window. The soldiers are sitting with heads bowed, deep in sleep. They are wearing purple uniforms with blue breast-plates and gaiters. They have blue helmets and each has a spear in his hand. The inscription reads: 'I am the Resurrection and the Light'.

This window was originally sited in the old mortuary, at the base of the tower, where it was inaccessible to the general public.

[34] Trinity College Manuscript Library, Dublin. Ref. 6008/661

[35] *ibid*. Ref. 6008/121

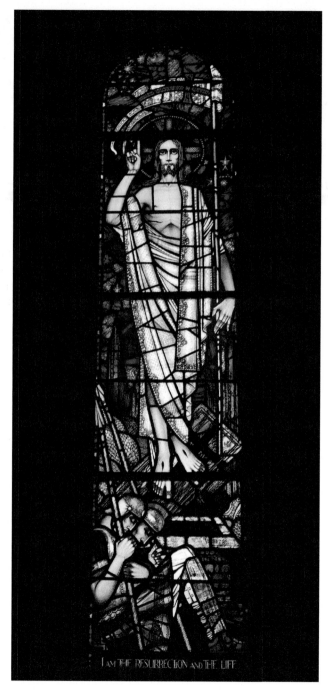

Figure 11 The Risen Christ (Clodagh Evelyn Kelly, Dublin)

During restoration works, carried out by the Abbey Stained Glass Company of Dublin in the late 1980s, the window was moved to the nave, on the right-hand side facing the altar from the village entrance, where it can be easily admired. It is a very fine example of Richard King's own developing style. While he has followed the rich decorations and colours typical of Harry Clarke, he has depicted the figures of Christ and the soldiers in a more realistic way.

Third Richard King Commission

In 1937, an order was placed for a two-light window in the baptistery. This rounded arch window depicts *The Baptism of Christ by St John* (Fig. 12). On the left-hand light, Christ is seen with his arms crossed, standing up to his knees in water, and surrounded by disciples. He has a white halo with a red cruciform and there is a white dove overhead, depicting the Holy Spirit. There are trees on the left-hand side, silhouetted against a background of deep blue sky. St John's hand, holding a small water jug with water flowing from it, extends from the right-hand light, in the act of baptising Christ. A small scene of the *Holy Family and St John* is at its base. This depicts Mary, in a deep blue hooded robe, and with a red halo. She is sitting on a purple seat with a mauve cushion. St Joseph is wearing a green robe and is holding a wooden mallet, one of his carpentry tools. A young Christ is standing nearby, wearing a pink and red robe, and he has a white halo with a red cruciform. A young St John is kneeling nearby, and he has a pink halo.

St John the Baptist is depicted on the right-hand light; his hand extends into the left-hand light, in the act of baptising Christ. St John the Baptist anticipated a figure greater than himself and foretold the coming of Christ. In his other hand, he is holding an ornamented staff, with a jewelled cross on top, and he is also surrounded by disciples. St John is wearing a multi-coloured cape over an orange robe. There is a small scene depicting St John, holding a staff aloft and preaching to a crowd, at the base of this light.

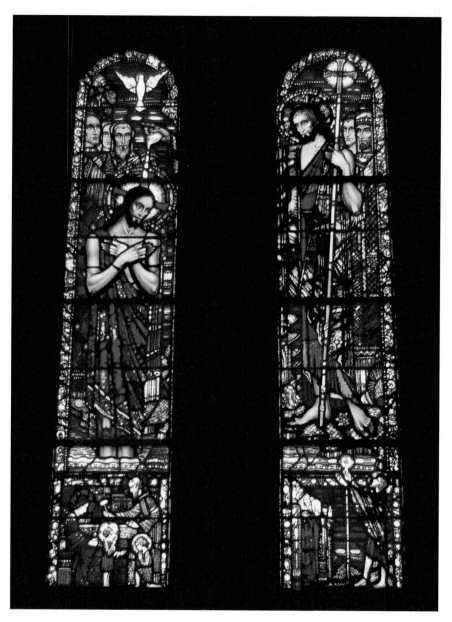

Figure 12 The Baptism of Christ (Clodagh Evelyn Kelly, Dublin)

Both lights are rimmed by a textured border and are on a deep blue background. Christ's robe is a vivid ruby red, and that of St John the Baptist is also red, and is topped by a multi-coloured cloak. All of the garments are richly ornamented. There was some quibbling about the cost of this window, which was constructed at a rate of £3.10.0d per foot. On 24 February 1936, Richard King maintained, in a letter to Canon Sheehan, that this was a reasonable price for the time. He said that 'if I do the window I shall ensure that it will be a perfect work of art'[36]. King has included darker and more stark colours in this window, as well as less detail. There is a pencil drawing of the window in the Manuscript Library of Trinity College Dublin[37]. This shows that the final work in the window is a little more detailed than the original drawing.

This window calls to mind the stained-glass windows in St Kieran's College, Kilkenny. They were also made by the Harry Clarke Stained Glass Studio, and feature a small scene from the life of each saint, at the bottom of each window.

[36] Trinity College Manuscript Library, Dublin. Ref. 11182/806

[37] *ibid.* Ref. 6008/606

Fourth Richard King Commission

In 1939, an order was placed for two small circular windows which were donated by Mrs Davy, a member of the well-known stockbroking family. These two windows are sited on the wall, to the left and right of the car-park entrance in the church extension.

On the right-hand roundel is an image of *The Apparition of the Sacred Heart to St Margaret Mary of Alacoque* (Fig. 13). Christ is on the right-hand side of the roundel and is looking at St Margaret Mary. He is wearing a richly decorated ruby-red robe and an orange undergarment. He has a blue halo with a red cruciform. He is standing, and is pointing to his exposed red heart. St Margaret Mary (1642-80), a French visionary with a special devotion to the Sacred Heart, is kneeling at the left-hand side of the roundel and has an orange halo decorated with red flowers. She is looking up at Christ and is wearing a grey cloak over a black habit. On the right-hand side is a small roundel inset containing a chalice with '*IHS*' (a monogram from the Greek, symbolising Jesus Christ). Above it, on the left-hand side, is a similar roundel inset with a crown-of-thorns motif. Both small-roundel insets are on a deep blue background with a white beaded rim. The inscription reads: In memory of Thomas Davy. There is a pencil drawing of this roundel, without the surrounding petal details, in the Manuscript Library at Trinity College Dublin[38].

[38] Trinity College Manuscript Library, Dublin. Ref. 11182/150

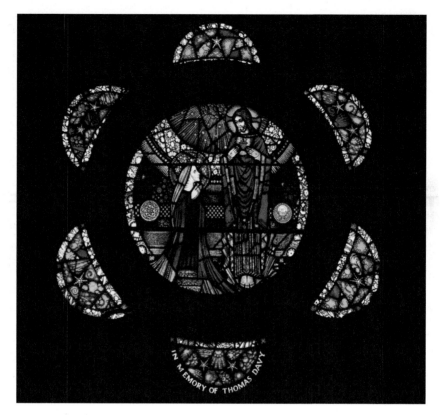

Figure 13 The Apparition of the Sacred Heart to St Margaret Mary of Alacoque
(Clodagh Evelyn Kelly, Dublin)

On the left-hand roundel is a depiction of *Christ Crowning His Mother, Mary, Queen of Heaven* (Fig. 14). Christ is seated on an ornate throne and has a golden crown on his head. He is wearing an ornate ruby red gown over an orange undergarment. He has a patterned halo with an orange cruciform. His mother Mary is kneeling in front of him. Her eyes are closed and her arms are crossed in prayer. She is wearing a deep-blue-coloured hooded cloak, a turquoise sash and a green undergarment. There are also two small roundel insets in this window with 'XP' (the Christian symbol *chi-rho*, from the Greek, a monogram of the name of Christ) on the left-hand side, and 'MV' (a monogram of the name of the Virgin Mary) on the right-hand side. Both small roundel insets are on a

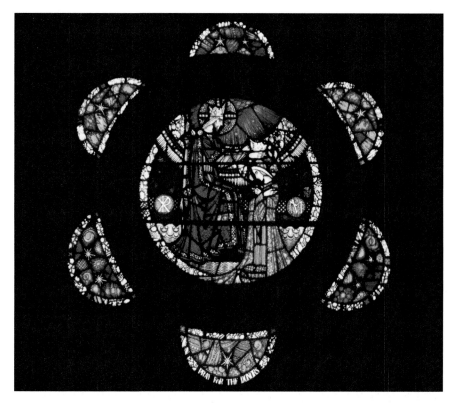

Figure 14 Christ Crowning His Mother Mary, Queen of Heaven (Clodagh Evelyn Kelly, Dublin)

deep-blue background and are surrounded by a white beaded rim. The inscription reads: Pray for the Donor.

These two circular windows cost £100. There was clearly some concern about the cost of the windows at the time. On 19 December 1938, Richard King wrote to Canon Sheehan to say that: 'We have not increased the price of these windows, although wages, materials etc have increased in price since the last two windows were erected, but we know that it would be rather difficult for you to prevail on donors to give a price in excess of that contributed by other people'[39].

[39] Letter from Harry Clarke Stained Glass Ltd, 19/12/1938, Terenure Parish Records

Richard King has continued the influence of Harry Clarke by using rich and vibrant colours in these two roundel windows, but his own more realistic drawing style is also evident. Both windows are in a daisy shape with a pleasing white-star motif, on a deep-blue and turquoise background, on the petals. The colours, of rich blues and reds, and the size of the figures on each of these roundels, were clearly chosen to balance and complement each other.

It is interesting to note that, while the above windows were ordered and installed in 1939-40, the church was not extended until 1952. These two roundel windows were moved from the transept of the original church, to the rear of the new extension. They were replaced, in their former settings, by plain coloured glass windows in similar outlines.

William J. Dowling

In 1940, William J. Dowling (1907-80) had taken over management of the Harry Clarke Stained Glass Studio. He was manager from 1940, when Richard King left, until the studio closed in 1973. During this time, the studio continued to grow: it produced a considerable body of work for customers, both in Ireland and abroad. It is believed that Dowling started in the Harry Clarke Studio at the same time as Richard King, in 1928, when Clarke needed assistance to meet the growing demand for his stained-glass work. Dowling was born in Dublin and educated at the O'Connell School. He studied at the Metropolitan School of Art (1925), while working in the Harry Clarke Studio, and exhibited at the Royal Hibernian Academy, showing eight works during the period 1940 to 1942. When the studio closed in 1973, Dowling continued to work as a freelance artist[40]. He was a strong advocate of the Irish stained-glass industry and recognised the potential for it both to create employment opportunities at home and to enhance the country's cultural image all over the world. Dowling credits Harry Clarke's commission for the Basilica of St Vincent de Paul, in Bayonne, New Jersey, for playing an important role in opening up the export market for Irish stained glass to the United States of America[41].

[40] Paul Donnelly, 'The Rise & Fall of Harry Clarke Stained Glass Ltd', M.Phil. dissertation, TCD, 2014

[41] William J. Dowling, Dublin Historical Review, Vol. XVII, 1961-1962, Old Dublin Society, Dublin, p.58

William J. Dowling Commission

In 1946, an order was placed for a large circular window by Canon John Sheehan, who was parish priest at the time (1929-50). The large rose window was to be placed high up in the gallery, above the organ. Cost was again a factor in this commission. Two possible scenarios were presented to the architects, Ashlin & Coleman, for consideration. One was for a decoratively painted stained-glass window, without any figures, in tinted cathedral glass[42], at a cost of £250. The second included figures, and was to be made in part pot metal glass[43] and fired, and the remaining part in tinted cathedral glass, at an overall cost of £500[44]. On 3 May 1946, William Dowling wrote to Canon Sheehan: 'We went very carefully once more into the price of the proposed new Rose window over the Organ Gallery and we find that we would not be able to reduce the price [from £500] without seriously interfering with the quality of the work[45].

A price of £500 was agreed, and on 9 May 1946 Dowling wrote to Canon Sheehan again, to say that 'this window will undoubtedly

[42] Cathedral glass is monochromatic sheet glass. It may be tinted, and is thinner than slab glass

[43] Pot metal glass is coloured glass in a uniform colour.

[44] Letter from Harry Clarke Stained Glass Ltd, 15/01/1946, Terenure Parish Records

[45] *ibid.*, 03/05/1946

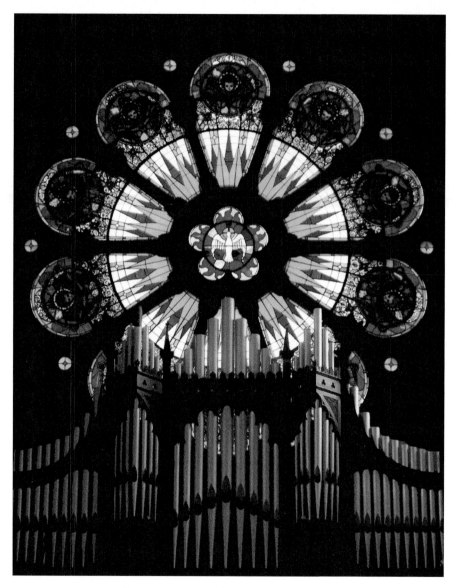

Figure 15 Holy Spirit Rose Window (Clodagh Evelyn Kelly, Dublin)

make a very fine appearance to the church and you may rest assured that we will take every care with it'[46].

The ten-petal, circular rose window has a very large kaleidoscopic design, with a brightly coloured *Holy Spirit* (Fig. 15) at its centre, surrounded by ten richly decorated small roundels containing angel heads. In Christian iconography, the figure of a winged dove is used to depict the Holy Spirit, the third Divine Person in the Holy Trinity (the Father, the Son and the Holy Spirit). The colours around the Holy Spirit – bright yellow, turquoise and white – are in sharp contrast to the dark reds and blues in the small angel-head roundels. The outside rim of the rose window is in a deep blue. While overall this is a rather plain window, there is some detail in the dark-coloured small angel-head roundels; this contrast makes an impact on the viewer.

This window has a very different look and feel to the other windows in the church, as there is no intricate drawing, and the use of plain, light colours, in the centre, contrasts sharply with the much darker colours in the small roundels. One can clearly see a dilution of Harry Clarke's influence in this window, which represents a departure from the more typical work of the studio. Perhaps there was less money around for stained-glass windows in the 1940s as a result of the Second World War. The general view, from the ground below, of this large rose window, is somewhat hampered by the organ pipes, which are sited directly in front of it. The pipe organ was bought from the Presbyterian Church in Glen Road, Belfast, at a cost of £20,000. It was purchased in 1984 at the instigation of Monsignor John Greehy, who was Parish Priest at the time (1983-2005).

[46] *ibid.*, 09/05/1946

Conclusion

Terenure developed, like many other areas in Ireland, from a place with many fields and few people to one of many people and few fields, and became a suburb of Dublin. The building of St Joseph's Church, and its growth, mirrored this development. The parish priests of the day were very forward-thinking in their support for indigenous Irish-stained glass artists, as it would have been the norm at the time to engage German or British manufacturers on such projects. As a result, we have been left with a unique example of the work of both Harry Clarke and, following his untimely death, that of his studio. The stained-glass windows in St Joseph's Church highlight some of the best examples of Harry Clarke's work, in particular his exquisite drawing ability and his use of deep, vibrant colours.

There could be more than forty different colours in a Harry Clarke stained-glass window, and he also often uses unusual combinations of colours, yet they never look garish. His drawings, and the details he includes, are still fresh and modern, even by today's standards. There have been discussions as to whether he was a better draughtsman than a colourist, but he was equally adept in both areas. Clarke's rich colours and craftsmanship, as well as his flair for imaginative and intricate details, are immediately recognisable in this church. William Dowling said that Harry Clarke was continually searching for perfection: 'sometimes he

found it in bold strokes, then again in the delicate and intricate patterns'[47].

The studio, which continued long after Clarke's untimely death, tended to work as a collective. This makes it difficult to attribute accurately who was involved in the drawing and design of each work. In a letter to a client, Walter Clarke confirmed that his bother Harry was responsible for 'the design, supervision and production of all of our windows'[48]. Indeed, during the latter part of his life, Clarke delegated much of the work to the artists in his studio, and confined himself, more and more, to a design and supervisory role. It could be concluded, therefore, that the subsequent managers followed Clarke's tradition and took responsibility for the design and other aspects of all windows under their supervision. While Clarke's own windows in St Joseph's Church are immediately recognisable, and stand out, nevertheless, the other windows in the church show how Clarke influenced the work that continued, after his demise, in the studio he founded. In the case of King and Dowling, they learned to work in Clarke's style, under his direct supervision. These studio windows show how Clarke's influence continued more strongly during the period immediately following his death and lessened somewhat there after. For example, the later windows lack his deep and dark colour palette and drawing details.

While none of the subsequent artists in the studio matched his brilliance, each added his own nuance to the delicate and intricate art of stained-glass design. Richard King continued to use the vibrant colours favoured by Harry Clarke, but his depiction of figures is more realistic and life-like. By the time William Dowling came to be responsible for design in the studio, many new

[47] William J. Dowling, *Dublin Historical Review*, Vol. XVII, 1961-1962, Old Dublin Society, Dublin, p.61

[48] Trinity College Manuscript Library, Dublin. Ref. 5998/692

churches were being built, both at home and abroad. As a result, perhaps money was not as plentiful, and a sparser, more pared-back approach was necessary to suit the changing times. Both artists, however, maintained the glorious use of colour, and the attention to detail, that they had learned from Harry Clarke.

There are examples of Harry Clarke's, and his studio's, work in every county in Ireland, as well as in Great Britain, the United States, Australia, New Zealand, and in the Caribbean and many African countries. This is a testament to the quality and craftsmanship of both Harry Clarke and the people whom he trained and influenced, and who succeeded him in the studio.

Overall, one could say that Harry Clarke influenced the design of stained glass in Ireland and lifted it from the influence of the dominant, and more bland, German and British manufacturers, which were more popular during his lifetime. It could also be said that his studio established a worldwide reputation, based on the genesis of his original approach to stained glass. The studio founded by Clarke continued long after his death, and examples of his work and that of his studio are a lasting testament, at home and abroad, to his influence. St Joseph's Church in Terenure provides a unique opportunity to see this influence and transformation, and to appreciate both Harry Clarke's own work and that of his legacy through his successors. The windows in this church are also part of Ireland's national heritage, to be enjoyed and appreciated by generations to come.

Bibliography

Curtin-Kelly, Patricia, *An Ornament to the City: Holy Trinity Church & the Capuchin Order*, The History Press Ireland, Dublin, 2015

Curtis, Joe, *Terenure*, The History Press Ireland, Dublin, 2014

Donnelly, Paul, 'The Rise & Fall of Harry Clarke Stained Glass Ltd', M. Phil. dissertation, Trinity College Dublin, 2014

Dowling, William J., *Dublin Historical Review*, Vol. XVII, 1961-1962, Old Dublin Society, Dublin

Gordon-Bowe, Nicola, *Harry Clarke: The Life & Work*, The History Press Ireland, Dublin, 2012

Harrington, Essie & Deirdre Brown, eds., *Memories of Terenure*, The Heritage Council, Dublin, 2000

Healy, Father John, ed., *Stained Glass Memorial Window, St Joseph's, Terenure, Souvenir of Dedication*, Maunsell & Co. Ltd, Dublin & London, 1920

MacGiolla Phardaig, Brian, *History of Terenure*, Veritas & Co. Ltd, Dublin, 1955

Strickland, Walter G., *Dictionary of Irish Artists*, Maunsell & Co. Ltd, Dublin & London, 1913

Turpin, John, *John Hogan, Irish Neoclassical Sculptor in Rome*, Irish Academic Press, Dublin, 1982

OTHER SOURCES

Argus newspaper, Dundalk, County Louth
Dublin Diocesan Archives, Holy Cross College, Clonliffe Road,
 Dublin
Freeman's Journal
Irish Architectural Archive, Merrion Square, Dublin
Irish Builder & Engineer, Dublin
Irish Times, Dublin
Manuscript Library, Trinity College Dublin
Terenure Parish Records

Index of Proper Names

Honan Chapel, University College,
 Cork 15, 24
Hugh Lane Municipal Gallery,
 Dublin 15

J

Joyce, James 2
Joyce, May 2

K

Kennedy, Mrs. Mary 39
King, Richard 35, 37, 39, 42, 43, 45, 47,
 49, 51, 54, 55, 62

M

McGonigal, Brigid 13
MacGreevy, Thomas 24
McQuaid, Archbishop John Charles 8
Meade & Sons, Michael 5
Metropolitan School of Art, Dublin 13,
 15, 35, 55
Miller, Bishop 18
Mount Melleray Monastery, County
 Waterford 39
Murray, John 2

N

Nagle, William 13
National Gallery of Ireland,
 Dublin 18, 21

O

O'Brien, Mrs M.A. 12
O'Connell, Sir John 18, 21
Orpen, William 15
Our Lady's School, Terenure 1

P

Pope Pius X 6, 8
Power, John & Teresa 8

Presbyterian Church, Glen Road,
 Belfast 59
Presentation Order 3, 12
Purser, Sara 14

R

Religious of Christian Education Order 1
Royal Hibernian Academy 55

S

Shaw, George, Bernard 1
Shaw, Sir Robert 1
Sheehan, Canon 39, 42, 43, 49, 53, 57
Simmonds, Charles 35
St Finbarr's South Parish Church, Cork 9
St John the Baptist Basilica,
 New Brunswick 9
St Joseph's Boys National School,
 Terenure 3
St Kieran's College, Kilkenny 49
St Mel's Cathedral, Longford 37
St Peter & Paul's Church, Athlone 37
St Teresa's Carmelite Church, Dublin 9
St Vincent de Paul Basilica, Bayonne,
 New Jersey 55

T

Terenure College 1
Trinity College Manuscript Library,
 Dublin 42, 49, 51

U

University College, Dublin 37
Union, Father Joseph 10

W

Walsh, Archbishop William 3
Wolfsonian Institute, Miami 15